ISBN: 978-1105526268

We Met the Space People
Helen Mitchell and Betty Mitchell

True Tales of the Weird and Wonderful

Pittsburgh, PA

2021

We Met the Space People

Helen Mitchell & Betty Mitchell

Helen's Story 7
Betty's Account 43

Helen's Story

It all began when my sister, Betty, and I were in a downtown St. Louis coffee shop. We had been shopping and had stopped off to get a coke and refresh ourselves. While in the coffee shop we were approached in a very mannerly way by two gentlemen dressed in grey suits, who managed to interrupt into our private conversation. As they spoke to us we found that they were from a huge mother-craft orbiting the planet Earth, and that their names were Elen and Zelas. They told us that we had been very closely watched by the Space People for the last

eight years, and that our progress had been noted off and on from the time of our birth. Betty and I were both inclined to think that someone was playing a silly joke on us and we laughed when they told us this, but they were not laughing and were serious and stern. We were strangely shocked, however, when they told us of a few incidents in our childhood that no one could have possibly known except the family. They told us that we had been selected as contacts by the people of space to serve as channels through which they could give certain information to Earth, and that we had been carefully watched, as I stated before. They told us of the reasons why the space people were coming to Earth and that they were here to guide Earth along the lines of Brotherhood and Science.

We were very much amazed at their words, and we noted particularly the kindness and warmth that shone in their eyes. With a single glance from them we seemed to sense the vast wisdom and brotherhood which they must have lived among. After talking with us for a little over two hours they left and told us they would contact us again, but it was not until a week later that we were impelled to again return to the same coffee shop.

When we entered the door we again saw one of the Space Brothers, and he gave us instructions at that time for building a device whereby we could contact the Space People. His instructions were explicit and precise, for he warned us that unless we placed every piece of the device in the proper place we would not be able to contact them with it. We were not

allowed to take the drawn diagram of the device with us, But we had to remember it as it was explained to us. When we obtained the proper pieces for the device we constructed it when we returned home, and were happy to find the results were satisfactory. We were amazed when we tuned in on the mother craft and spoke with the same person we had earlier seen. We were also allowed to speak with the commander of the craft, who at that time was known as Alna. In the following six months we spoke many times with the space people through the device, and received much information about their homes, sciences and craft.

In November of '57 I was alone in downtown St. Louis on business when I was again contacted by the space people and at their request went with them by automobile into

Illinois where we drove to a heavily wooded area. There, I was told, was where they landed when they had business or contacts to make in St. Louis. Settled back behind an old barn was a circular craft that I judged to be approximately nine feet in height, and about 38 feet in diameter. It had a domed top, but no portholes. The sliding door was open and there was a uniformed operator sitting at the controls.

I was nervous although I knew no harm would come for me, and I was visibly shaking, but Zelas only smiled as though to reassure me. The flight to the mother craft took approximately 15 minutes, and I was told the magnetism of the small craft would not affect my watch since it would be balanced by the magnetism of my own body. However, while in the mother craft the magnetism of it caused my

watch for stop, and it was de-magnetized in a small machine before I left.

Inside the mother craft we entered the huge receiving room for the smaller craft. There were many huge machines in this room, and there were also many other uniformed men standing around obviously working upon the machines or moving them about. They glanced at us when we entered, but then returned to their work as before. The hall that we entered was softly lit and was curved both at the ceiling and comers. We entered the first room to the right which appeared to be a room for relaxing. There were divans and contoured chairs with white upholstering that had a thread or design of a golden hue woven in it. The room was meticulous and vast, and as I stood observing the beauty of it three uniformed men

approached us. Their uniforms were of a blue-gray color with a slight metallic look, and I learned the jodphur type boots they wore were actually attached to the uniforms, and were not a separate piece of apparel. The uniforms were soft to the touch and the texture of velvet. I was then introduced to three men and learned that one was Alna, the commander of all craft operation upon Earth. Alna spoke with a very heavy accent, and was much darker than any of the others. His skin had a high bronze tint to it, as compared with the lighter complexions of the others.

From this room I was shown the control section where I was told our calls were received when we operated our device. Here they placed a call through to our telephone in St. Louis by adjusting a series of dials, and I was allowed to

speak with Betty and tell her that I was with the Brothers. I was also shown a scope similar to a television screen, the only difference being this was at a slight elevation on the control counter, instead of standing up at eye level or in a box type cabinet which our television sets consist of. This scope could obviously reflect any particular building or house that the space people desired to observe, and when I looked at the scope when Alna requested me to do so, I could see the inside areas of my home and could see my sister, mother and the children moving about. It was as though the entire roof had been removed and only the walls remained of the house. When I asked them how this was done, they explained that the first set of vibrations that left the roof were erased and the vibrations of the furniture and people inside were received on the scope, and therefore it appeared as though

the instruments in the control section were actually looking through the building.

From this section we entered another much larger control section and I watched other uniformed men going about their work with much deftness and swiftness. I was told then that we were going to dine, and when we entered the dining area it appeared as a vast empty room. However, tables and chairs rose from the floor section, and I dined with them after humbly and respectfully listening to a prayer Alna said in the Universal Tongue.

The food consisted of three different types, and a drink similar to apricot nectar was enjoyed. There was little conversation during the meal, and when all had almost finished Alna told me I could witness a dance performed by two of the Space Brothers. This dance was most

unusual and fast, during which the two men passed a small object from one to the other, sometimes throwing it in the air and catching if before it fell upon the floor. I expressed my thanks to Alna for allowing me to see this, and when we left the dining area we moved down the hall to what obviously was an entertainment room where the Brothers spent many relaxing hours. Many men were in the room, some sitting at tables and others playing a game similar to our Shuffleboard. I was asked if I would like to try the game, and after watching Alna I understood simply how it was done.

A round colored disc about four inches in diameter was placed on the floor in a particular square, and by mind power alone the disc was to move across the floor to another particular square. This section of the floor was

electrically charged and receptive to the thought waves leaving a person's mind. Alna took a blue disc that was handed to him and placed it on the floor causing it to move a considerable distance. Then I was handed a red disc and asked to try. I was doubtful if it would work for me, and the only thing I could think of was to silently command the disc to "Go." I was amazed when the disc moved slowly up the floor, but quite some distance from that of Alna's. When I glanced at my watch and noticed it had stopped, it brought Alna's attention and he said for this time he felt I should not be held up longer from my other activities, and that a second trip would be longer. It was then that he took my watch and placed it in a small machine in the first control section and then set it for me, obtaining the proper time from a scope that contained many symbols and crossed lines on it.

Then with Zelas and Benen I returned to the craft receiving room and entered again a smaller craft with them. I do not know exactly what series of air locks the craft enter and leave the mother craft, but there was a large dark section upon the floor in the receiving room and as we entered the smaller craft to leave Zelas pointed it out and told me that was area where the craft left. The trip back was quick and short, and as we drove back to St. Louis I recounted in my mind all the things I had seen. Being alone, I wanted to be able to tell anyone else as much as I could; however, we decided that we would not then tell everyone else of our experiences until we had enough information to relay to the public. Last year at Buck's Convention we were called upon to speak, but we were neither prepared nor expecting that we would be called upon for a speech. I did, however, say a few

words and since that time we have delivered several lectures to various groups.

A few weeks later we were contacted by the Brothers and were told that the Martian Council had requested us to speak of the powerful effects of the A and H bombs and also the future of those responsible for their evil. When we were told these requests we asked, for information to give Earth's people, and the following is what they gave us. It was prepared by one of the Brothers known as Sigt. I will go directly into his message and then would like to take up a subject that many people have questioned us about such subjects as evil flying saucers and evil space people, also strange phenomena that seem to defy natural law will be spoken of. Now, I would like to give you Sigt's message:

"Earth's scientists are creating around planet Earth the most deadly condition to material man than ever. The explosions of the A and H bombs are placing the residue particles of radioactivity into all the materials of Earth. Each human being upon Earth now carries a certain degree of radioactivity in their bones and systems. Why should it be significant to hear of this when you cannot see the radioactivity, nor hear it as it does much destructive work?

"In the advanced laboratories of Mars we have proved the destructibility of such uncontrolled energy. Radioactivity drops, upon the grass, buildings and people after being carried by the air currents around an explosion. This energy is in minute particles that have the effect of deterioration to the molecules of all material things. This radioactivity settles around

an object or body and penetrates the outer area of the surface or skin. What does radioactivity look like you may wonder.

"As an explanation, many of you have seen small dust spirals along the streets or in a dusty area that swirl around and around in circles that then seem to disappear. Radioactivity has the same effect and looks very similar as it settles around a body. The small particles are caught up in a swirling counter-clockwise motion that causes them to be driven down into the surface of the body cells. This energy, once inside the body, off

them.

"When this new activity occurs in a normal cell a powerful microscope would reveal the atomical structure of the cell is creating a counter offensive action that is clockwise as compared to the counter-clockwise motion of the radioactivity. When this occurs, there is eventually a breaking down of the cell's motion, for as the explosions of the A and H bombs continue the action of the radioactivity is strengthened by this and overpowers the clockwise motion of the body cells that are attempting to throw off the radioactivity. Thus, the body cells are forced to become activated in the same manner. This creates a drawing together or construction of the cells and creates abnormal conditions and illnesses. As the radioactivity increases the rate of motion

increases around each body living on Earth. This changes the cell formation and in the next generation this inherent condition is accentuated by the accumulated mass of more radioactivity. In the second and third generations these changes are visible as definite deformations of the body, and this in turn, if not controlled, will lead to a generation of mutants.

"What does radioactivity sound like? I will try to explain. Many people are receptive to certain high vibratory sounds that are derived from the atomic explosions, and are the elemental changes in the atmospheres of Earth. These high pitched sounds are very serious, for they can almost pierce the very soul consciousness, and cause changes there. The consciousness of Man is being affected every day by these vibrations that these explosions

have created, and unless these are altered or until the explosions of this nature are stopped the Mind of Man will be changed in drastic measures. Some of these notes can cause a perfectly healthy person to develop a fatal illness, some can affect the mental processes terribly, other of these vibrations, if not altered within the consciousness of the individual, can cause one to commit acts that otherwise would not be done. But most serious indeed are the changes in the! atomical structures of the atmospheres of Earth. Here the greatest battle of all is arising. The Earth wants to separate with this activity, but the consciousnesses of the higher evolved here upon Earth and in Space are preventing this, until Earth can adjust.

"How can you stop this from happening? The answer is simply stop the unnecessary tests

of these bombs. For those who maintain it is necessary to show the military strength, we can only say what strength is there to be shown that deprives the people, vegetation and animals of a perfectly beautiful and attainable future otherwise. Is it truly possible that the deceivability of such destructive weapons can replace sane, sound actions of better living? It is necessary now for the Space People living upon Earth to take protective measures or otherwise suffer the same effects from radio activity as the citizens. It is not possible for us to give Earth's people enough of the protectors without the co-operation of the governments, and such cooperation is at present unattainable. The continuance of these tests are affecting all responsible for them, and if one accepts reincarnation as an answer it would be definitely seen why no one here or responsible for these

tests would want to re-live again in mutated bodies of the future generations. If reincarnation be unacceptable to the average person, then the knowledge that these tests are mutating their children and their children's children should be sufficient reason for stopping them. Our warning to Earth is cease your tests and save your future."

What the Space People are trying to make clear in this message and many others similar to this is that Earth is now in a most perilous situation, and faces self-destruction of humanity. In the two years we have contacted the Brothers they have been concerned and talked most frequently about the destructibility of the A and H bomb. Speaking of this destruction, the questions I mentioned earlier come to my mind, and that is concerning the

evil flying saucers and evil space people.

First, we must consider the evidence presented. There have been saucers that were reported as having a negative effect upon people by burning them or causing nausea, etc. And in some instances there have been cases reported where people have been assaulted by beings that have emerged from some saucers and actually attacked them. The descriptions of these beings have been generally of a small type of people who were unusually crafty or mischievous and who actually grasp people and attempted to drag them into their craft. Where do these beings come from, and why are they entering this system? No doubt most of you will agree there is a tremendous battle going on between the good and the bad, which concerns all thoughts, actions and influences. From thousands of years

ago to the present age this battle between right and wrong has been waged against civilization and has balanced first in favor of the good and righteous, and then turning and swaying in favor of the wicked or evil. This strange course of events has been necessary for certain conditions to prevail upon Earth, so that beneficial results would come about. The devastating bubonic plague that swept Europe in the Dark Ages was indeed a terrible thing and was judged to be just that by the people, but this negative condition actually paved the way for more sanitary conditions. All evil will give way to the good, and all wrong has a right.

The space people that have negative qualities about them are coming from farther space systems, although I do not wish to imply that all space craft from farther systems is evil.

Many of the craft from farther systems are very good and are also trying to help Earth; however, it is only those certain evil systems that we should consider when I say those from a farther system than our own. It is these negative beings who are here for the purpose of actually taking people from Earth to indoctrinate them with their ideas, so they in turn will cause confusion and disturbances upon the planet. The true purpose behind this is to prevent harmony and peace, for they are in alliance with those beings living in Earth, who themselves will be forced to leave Earth when peace and brotherhood is completed. The gains that these negative people obtain from their alliance with those other negatives in Earth is not known by us, but it must be quite profitable for them to engage so actively against the Space Brothers who are trying to help Earth. The Space Brothers who

are trying to help Earth have to contend with these craft and beings from other less desirable systems, and also have to contend with the disbelieving masses of people who either do not know of the need for harmony and peace or those who do not want to listen to their urgent requests. The job of the Space Brothers is not easy, for it is necessary to prepare the people of Earth to accept their existence, and also to guide them in proper understanding so that peace and co-existence will be possible.

Many people seem to feel that the negative beings are only from planet Earth and consists only of those fallen angels who were cast out of heaven by a Supreme Command from the Most High. Many can quote the proper passages of the Bible and prove that there are fallen angels living here on Earth, who cause the

necessary confusion and evil which we here must live among. There are those intelligences of superior powers whom we would call fallen angels living in Earth, but it is not wholly from them that the evil or bad flying saucers come. As you look up into the sky at night you see multitudes of stars, planets and suns moving on in beautiful orbits. However, if you could move out through space and watch the barbarous conditions that exist upon some of these stars you would be shocked. There are some systems advanced in scientific accomplishments to the degree of mastery over space, but those systems have advanced in science alone and have little spiritual advancement. They come here to Earth and to other planets in farther systems to form alliance with those intelligences who will provide them the necessary fulfillment of their evil desires and wishes.

Planet Earth is now visited by such craft, whose occupants live and profit from the unrest and disharmony present. Who can truly say what percent of our actions are fueling these beings with necessary materials and profit. What these profits are cannot be said by us, for only each one of us in our own understanding can know in Truth what their actions consist of that could be used as a fuel by the negative ones. These negatives can present very good arguments and can deceive the unwary in many ways. Their goal is to conquer and own, without any concern how they do it. They may use one form of attraction one time and another the next. Now, how, you probably think, do we know about this. I can only say that many times, more than we have recorded or remembered, we have been interrupted in our attempts to contact the Brothers by means of our device, and then

encounter the beamed transmission of a negative craft. In many instances these beings have mocked our efforts and have belittled the Brothers and us. Other times they have lied and said they were the M-4 Section of Mars and they had a message for us from the Council, and that we were to say such-and-such or else we were to stop speaking altogether. Patience is a good way to win with their persistence, for they cannot persist too long without getting angry and revealing themselves. Once we were interrupted by them and told flatly who they were and what they wanted us to do. They asked us to prepare a book for them and expose the whole untruth connected with the story of the fallen angels. This book was to be delivered by one of their very advanced minds, and to be created in manuscript form by us and offered for publication.

Please notice that I said this book was to be done in this manner at their request. We refused to do as asked by them, and burned the first few sections of their story when it was delivered to us. From that time up to the present we have been interrupted only occasionally, and then their attitudes have not been quite as demanding. We refuse to have anything to do with this type of beings and wish to serve only those of goodness and light.

The subject of negative beings can be connected directly with much unusual phenomena that seems to be completely contrary to natural law. However, nothing can defy the absolute laws that God created, but many of these laws are simply not known nor understood by millions of people. The percentages of people who can manipulate these

laws is very few. As said before, many beings of a negative nature do live in Earth, and there are some of these who have the power to do unusual things. Many times strange phenomena have been noted to take place, such as objects moving freely in the air; articles appearing and disappearing; solid objects passing through walls, door, etc. The number of unusual happenings are numberless. Many of these happenings are due to the mischievous minds of negative beings, who merely change the molecular polarity of the structure of an object and cause it to pass through the air as though defying gravity. Truly such an object is moving freely through space, but only due to the natural law of gravity.

If an object such as a glass contains the positive polarity of mass, then the earth below it

is of a negative polarity. Merely by changing the positive polarity of the glass to a negative polarity it will cause the glass to push away from the earth which is also of a negative polarity. The law of a magnet can be applied to this simple demonstration, for "Like polarities repel, and unlike polarities attract." Two negative polarities will push away from each other, whereas two polarities of different natures will cling to each other. Thus, gravity, or more simply said, polarity controls such unusual demonstrations. It does, however, take a very great Will Power to command such objects to move. Nothing can be done outside of natural law. Misapplied power and nonsense must still obey the laws of God, for nothing can be outside of His Laws. An important thing, however, is that not all unusual happenings are the result of negative beings, but much of it is unknowingly

set into motion by the minds of Earth people, who happen to set into motion the law of polarity and gravity.

I would like at this time to dispense with the subject of negative things, and like to direct your thoughts to something of a more affirmative nature. I would like to give you a little of the prophecy for Earth that the Brothers gave us. However, at no time do the Space People or Betty and I want you to think that these prophecies are definitely what will happen to Earth. The Brothers told us that these things would happen only if Earth follows the path of advancement that she had been doing before the explosions of so many bombs. These explosions could alter these conditions very much, for as the Brothers said, these explosions are altering the atmospheres and materials for Earth. It is

from man's past actions and advancement that these prophecies are derived, and it is from this that the future is formed. Thus prophecy can change and 10 years from now these same prophecies could be wrong, but only if Earth's people continue with the A and H bomb explosions and if a series of serious battles and conflicts result upon Earth.

As for the prophecies themselves, the Space People tell us that Earth will have an axis change, and that this will cause America to become warmer and certain parts of Europe to become colder. This axis change should come about slowly and be a gradual thing, and will be if nature is left alone; however, there are certain people who wish to bring about this change too quickly. As for the manner of clothes people will be wearing upon Earth in the future we will

see that the men will wear clothes that have a tighter fit, whereas the women will wear looser and longer dresses. The homes will change with the circular home being preferred. There will be a screened dome top to the homes, which will open to let in the air. Lighting will be from the walls and a circular rim around the ceiling. This lighting will be automatic and adjust itself to the proper brightness. All power for the kitchen, laundry, heating and lighting will be provided by small individual units in each home that is inexpensive to operate. The countryside will be beautiful, for all wires, telephone poles and power stations will disappear, along with the billboards and other unsightly scenes.

The entire mind of man will enlarge in spiritual growth, for unmoral books, shows and entertainments will be revised to teach Truth.

Television will be the greatest channel for Truth to reach the minds of the people. As the mind of man changes to higher thoughts, so, too, will much of the material requirements change. And it will come to pass when the dietary habits of man will also change. No longer will slaughter houses be seen, for the eating of meat will diminish. It will not entirely disappear, but the vast slaughter of animals will cease. Earth will cease to have epidemics of disease, and therefore newer systems of laboratories will appear. Illness itself will be an individual thing, and will be corrected, quickly and safely in the laboratories. What more can we ask for, for doesn't this sound like Earth could be a beautiful place? There is more--much more--but time does not permit me to enlarge on all the prophecies for Earth. Among the many things to happen, Earth will also have space flight, and

will enjoy the companionship of the Space People. When Earth has risen to this height of advancement space flight will become a common thing, and Earth's people will then perhaps go out and serve other less fortunate planets, just as the Space People are serving Earth now.

There are only a few more things I would like to mention and they are concerning a question which has been asked of us. A few months ago Betty and I announced that we were publicly withdrawing from actively speaking. But since that time an erroneous idea has sprung up that perhaps we had been shut-up by the Three Men in Black. We would like to clarify this, for we have not been visited by anyone who threatened us, and we were temporarily withdrawing from the saucer field for personal

reasons. These reasons were due to certain changes we were going to make, and one was due to the fact that I was going to leave for France. However, different plans have been formed and I am not going to leave for France; therefore, we will be available at times for lectures and speeches.

Betty's Account

When Helen and I made our Preparations to go to a UFO convention we felt It would be interesting to get as much direct Information as we could from the Space Brothers, so when we contacted them we asked if there were any definite statements they had to give us. We received a lot of information from the M-4 Section on Mars and Helen presented it in her earlier comments (above), but we also contacted the Planet Venus and received much interesting information from a Venusian called Tregon. I would like to read his message for

you, which we received just a few days before we came down here, so without any further comment at this time I will quote the message from Tregon of Venus:

"Often the revised facts of Earth's history come to our attention, for the credibility of the human mind is filled with much misrepresentations. As our sciences developed on Venus we were able to devise machines capable of picking up the past actions of history and by a series of transformers create the scenes and sounds of unforgotten history. Many scenes that have been completed on Planet Earth have been viewed, and it is with understanding that we realize the means of recording for Earthman were inadequate. Barriers of language and habits prevent the Interpreters from knowing what ancient man meant by his words and

phrases which he left as a record of his deeds and actions. Languages that have long since ceased being spoken or learned create much of the present man's difficulty in comprehending what his ancestors meant by certain symbols and figures. The present stage of man cannot possibly know what was in the thoughts of the ancient man, who left as a record chipped symbols and signs upon rock and marble. The dead languages of the past create the insurmountable barrier, for it was thus the purpose and plan of the Creator to prevent the understanding of certain tribes. When the decree was given to have the tribes split and the languages differ upon Earth it was for the purpose of veiling the darkness from the untrained mind of the evolving souls living on Earth. Thus the sealing up of ignorance and the fallen angels began.

"As history proceeded the decrees of those possessing the wisdom of darkness grew until they recorded much false history that glorified their deeds. The sons and daughters of man had learned the wisdom of entering heaven, but falsely used the illumination they gained and instead of living according to the proper laws they built and obtained material creations to satisfy their bodies. Thus the spiritual advancement of man was prevented from properly developing, and the decree of severance and chaotic thought filled the Earth. Much time passed before this was completed, for it was from Venus that the messengers came to start these changes. Changes came and flooded the Earth and the separation of people began. Through these many years the Greek civilization came arid passed, leaving it's imprint with the only means of communication

known then, but those of different language found they could not comprehend what the ultimate motive for certain symbols was and as the vast civilization of the Greeks fell into obscurity so, too, did the true meaning of their records. Roman history came also and then left, along with the Egyptian rulers and people; but none of this history is known today in it's true sense. The language barriers are definite and profoundly confusing to the minds of man who tries to surmount them. Earth man was thus protected from himself by this severance of language, for the wisdom of some historical periods and people would have been destructive. Those people who came to Earth, being sent by the Creator in His wisdom, served to prolong the advancement of man and his material creations, for it was known that Earth man could create anything then that his imagination would

reveal.

"Earth man had reached an evolutionary cycle where he responded to the intellectual flash of creation that was born from his mind. He could see mental images of vast material creations inspired by the elevation of his thoughts, and in disobedience to his spiritual growth he sought to satisfy this and create similar effects. Knowing the effect this would have upon the development of his mind the messengers of Venus came to prevent the destructibility of man. The True Creator was no longer exemplified in man's mind, for it became filled with the material wonders devised in his imagination. The centuries of advancement that Venus had, before, Earth knew the trend of man's feet, placed her people in a position to see the evil that Earth was committing. Those

wicked people who, during the rise of Earth's own civilizations, had been cast down to Earth were creating monarchies of slavery of Earthman.

"This time in Earth's history was during the Atlantean period, and the separation of Earthman's minds was decreed to take place. Those from Venus came, and gave warning to the faithful of Earth, who, unlike the other Atlanteans, followed the laws of the Most High. The story of a man called Noah, in your Holy Book, was one of the faithful who survived this cleansing of Earth. Those unfaithful of Earth who followed the fallen angels were deprived of their powers to control by the division of the Universal Tongue. No longer could one language be understood by another, for the different ones of faith who were saved created

various dialects and interpretations at the guidance of the messengers.

"As a means of preserving their might and power the Atlanteans wrote upon stone tablets and inlaid their writings in marble slabs thinking men in the future would look upon his recordings and wonder at their power. Now, their magnificent temples and homes lay beneath the ocean in obscurity, lost forever to the minds of man. The tongues of the Earth are many and varied, for not even two people of the same tongue use exactly the same phrases. It is possible for those of the same tongue to understand each other's ideas and words, but when one interprets the language of another into their .language some of the true meaning is .lost. This is the diversion of the tribes of man as decreed by the Creator. In the age of the

Atlanteans the evils of Earth were ri1ultiplied by the Evil ones who fled from the exploded planet called Lucifer, and who created the same evil on Earth as they had created on their planet. False worships grew and multiplied on Earth at their direction, and the fallen angels of Lucifer lead astray many of Earth's inhabitants. Seeing this, the wise ones of Venus came to Earth in their craft. Earthmen called these craft "fiery-chariots," and a "wheel inside a wheel," another name given to the craft of Venus by Earthmen has been a "cloud."

"The years of Atlantis saw a growth of intelligent comprehension in man, and it was through this growth that man's eyes became open to the evils around him. He no longer lived in a world of innocence and obedience, but the people began to follow the evil influences that

the fallen ones of heaven had brought with them. Earth was then polluted, and as a new cycle of change in the heavens began the wise ones of Venus came to Earth to warn all to repent, but many did not follow their guidance. Being wholly instructed by the Most High Council the Venusians who came to Earth told the faithful to leave for certain areas, and thus the Bible tells of only the one story of a man called Noah, who with his family built a means of sustaining the change which was to come to Earth. The wicked and evil ones died in the axis change and cataclysms that occurred, while the faithful were saved by proper warning according to the order of the Most High.

"Again now, we watch Earth follow the path of Atlantis. Terrible releasing of energy in bombs is making your Earth a place of

desolution. Plants and animals are being scourged by it, and soon even the water will become undrinkable due to the radioactivity of these bomb releases. Our help can only come after a certain length of time has elapsed from the one cataclysm to the next. We can offer our warnings, and guide those who are faithful to certain areas, but we can not ourselves move to stop the tests of the bombs. Earthman brings upon himself unnecessary tribulation. The question of another major war is asked many times by Earth people, and we say that there must not be another war. The Truth in your Holy Book will come to pass, for we see again the evil works Earth does and the Most High Council can rule at any time upon the necessary actions. We repeat, we cannot intervene in your bomb tests, for the will of Earthman must be fulfilled; so, too, must the Law and if such evil

actions of man do not change we will lift the chosen people to watch from afar the rest of Earth's woes. Let those who have ears to hear, let them hear." Signed, Tregon of Venus.

I have a few comments to make concerning this message from Tregon of Venus, for I was very much interested in knowing of the rise of Earth's earlier civilizations, particularly the Atlantean. Many people have asked us of this phase in Earth's history and so it was natural that we would prefer to obtain the Space Brothers' opinion. So many really important facts are contained in Tregon's words that I would like to draw your attention to a few in particular.

At the first of his message he said, ". . . the human mind is filled with much misrepresentation." Then he went on to say how

false history is accredited to this misrepresentation, and he explained why this came about. We all know that many of the facts in our history books are based only on a few records and that these could have been hurriedly and falsely written or transcribed. The plain truth that any of the ancient languages cannot be completely understood today is due to the fact that the human mind is divided in it's wisdom, and that certain knowledge then, does not prevail today. Therefore the present mind cannot possibly understand all the phrases and written symbols that the ancients tried to reveal in their records. Our explorers and archaeologists are now finding and uncovering strange records and symbols that they cannot decipher. A language of symbols was the only way to record the Universal Tongue. The people of ancient Atlantis spoke the Universal Tongue, and as we

recall in the message of Tregon, he said that due to evil acts the people and tribes of Atlantis were split and I quote his words, ". . .it was thus the purpose and plan of the Creator to prevent the understanding of certain tribes." We learned that the fallen angels were the beings who lived on the planet Lucifer, that once was in an orbit between Mars and Jupiter, and that these evil beings fell to Earth after refusing to accept the word of the Most High Council. We can understand why these beings were considered as angels and why they are considered as falling from heaven to Earth. At the time of Atlantis the beings upon the planet Lucifer were extremely advanced and possessed Space flight and wisdom that Earth man does not yet even know. They were thus advanced far beyond the modern men of Earth, and were indeed possessors of rare wisdom.

Their fall occurred when they disobeyed the Most High and continued with devastating experiments that caused their planet to be exploded. Thus cast out by the Most High and the other angels they descended to earth where they were forced to rebuild and start a new. They had lost a vast and beauteous planet, and thus fell to the early civilizations that Earth possessed at that time. They continued their evil on Atlantis and when the Angels in heaven saw this they were commanded by the Most High to cause this to cease by scattering the people and dividing the language, so the evil ideas of the fallen ones would not be understood. When the messengers from Venus arrived to start the work of the Most High, Tregon tells us that, ". . . the sealing up of ignorance and fallen angels began."

Since the space people of Venus did instruct and guide the faithful people of Earth to sacred places where they would be safe when certain changes took place, we know that they will again do this at the proper time. Our scientists know that there are cycles of activity that Earth passes through and Tregon also said in his message that ". . .as a new cycle of change in the heavens began the wise ones of Venus came to Earth to warn all to repent." The people of Venus knew of the inevitable axis change that was to bring a flood and cataclysms to Earth. The faithful were warned and only those who were full of obedience to the Most High received the warnings and instructions. Thus Earth was cleansed and the evil ones with their records and language sank with Atlantis and other continents, while the faithful were saved.

We find the space people are now prepared to again warn those who are faithful and to show them sacred ground to go to, also to lift them from the face of Earth itself and protect them from the radioactivity and evil of those who do not follow the laws of .the Most High. Our Space Brother has said, ". . . Let those who have ears to hear, let them hear." Tregon has told us that the evil of Earth will continue until the planets and oceans are radioactive unless Earthman puts a stop to this evil.

The space people cannot intervene, nor cause all the A and H bombs to become inactive, for they, too, are held in a certain status until the time comes when the Most High issues a decree of action for Earth. No doubt they have the wisdom and means of making all the storage of bombs inactive, but they will not or can not

interfere unless the order is given by the Most High. The Brothers have told us before that the evil ones of Atlantis were experimenting with energy releases that our scientists are playing with today in the A and H bomb experiments, and that due to this they brought about the axis change more quickly than the natural change would have been. He has told us the tribulations of Earth could be brought about too quickly, for an axis change is coming and if left unhampered it will be natural and slow; but if the explosion of bombs continues it could bring about this axis change too quickly and cause cataclysms.

Many times the enthusiast asks us, "Why don't the Space People just come down and take over? Earth would be better off." But Tregon has answered that question, and until Earth is again ready for the natural axis change they will

only issue warnings and perhaps take the faithful up to the far heavens where they will wait the final cleansing of Earth's surface.

The problem of flying saucers has become very deeply interwoven with the fate of Earth, and none who investigates the phenomena can come out of it without sensing the complexity of the solution. No one can give a definite account of all the Space people's purposes, but we can share the information we do get and piece together the intricate puzzle of what they are, why they come to Earth, and how Earth is being benefited by them. To the faithful who keep the Laws of the Most High we can only phrase the words that so often come to our minds, ". . .rejoice, and be exceedingly glad: for great is your reward in heaven. . . . "

www.ingramcontent.com/pod-product-compliance
Lightning Source LLC
Chambersburg PA
CBHW072207170526
45158CB00004BB/1793